A BOOK
OF
HOURS

A Book
of Hours

John Reeves

WILLIAM B. EERDMANS PUBLISHING COMPANY

GRAND RAPIDS, MICHIGAN / CAMBRIDGE, U.K.

© 2001 Wm. B. Eerdmans Publishing Co.

Wm. B. Eerdmans Publishing Co.
255 Jefferson Ave. S.E., Grand Rapids, Michigan 49503 /
P.O. Box 163, Cambridge CB3 9PU U.K.
www.eerdmans.com

Printed in the United States of America

06 05 04 03 02 01 7 6 5 4 3 2 1

Library of Congress Cataloging-in-Publication Data

Reeves, John, 1926-
A book of hours / John Reeves.
p. cm.
ISBN 0-8028-4907-5 (cloth: alk. paper)
1. Christian poetry, Canadian. 2. Catholic Church — Liturgy — Poetry.
3. Books of Hours — Poetry. 4. Church year — Poetry. I. Title.

PR9199.3.R425 B66 2001
811'.54 — dc21
2001023822

The line illustrations preceding the section-title pages are taken from Alva Steffler's
Symbols of the Christian Faith, forthcoming from Eerdmans.

The photograph depicting the clock gears is courtesy of Steve Richardson.

All other photographs are courtesy of PhotoDisc.

For
ROGER REYNOLDS,
Mediaevalist,
Mentor

Table of Contents

IV. CONCERNING THE RESURRECTION

V. CONCERNING THE ASCENSION

Preface

In the Middle Ages, when Christianity was at once the foundation of European civilization and an omnipresent fact of everyday life, religion was not confined, as it so often is nowadays, to the interior of a church. To be sure, communal worship was of paramount importance, especially in monastic houses. But the secular world was full of rites and customs that gathered all aspects of human activity into the fold of faith. People were baptized in the faith, married in the faith, and buried in the faith. Ploughs and crops were blessed in the country. In the towns, merchants and tradesmen formed guilds to present the mystery plays. Pilgrimages were common, and crusades were mounted. Ecclesiastical courts wielded wide judicial powers. Legacies were bequeathed to sponsor prayers for the souls of the dead. Education was in the hands of the clergy, as was the care of the sick, the orphaned, the mad, and the destitute. In short, the laity, no less than the tonsured, lived out their time on earth with one eye constantly on heaven.

In those years, the majority of the layfolk, being illiterate, imbibed the message of their faith mainly through the vernacular word, in homilies: the Latin of the Mass and other services was, in itself, incomprehensible, though repeated exposure to it gave it a familiar ring, inspiring a kind of reverence; and a few simple prayers, like the Paternoster and the Ave Maria, were recited by rote and were fully understood. However, it was not through liturgical words alone that layfolk absorbed religion when attending church: their souls were uplifted by the soaring beauty of Gothic architec-

ture, and by the matching beauty of the Gregorian chant; their sensibilities were stirred by the ceremonial richness of worship, by the vestments, the candles, the incense, the ritual gestures; their sense of magic was catered to by the cult of relics; and their fondness for stories was enshrined in the images of stained-glass windows. All these factors entrenched the faith firmly in parishioners who lacked letters but longed to have meaning in their lives.

Coevally, there existed a small class of educated laypeople, raised in privilege but equally indoctrinated with the Christian culture that was their environment from birth to death. These were the rich who commissioned artists to beautify altars with religious paintings; who endowed ecclesiastical buildings of great architectural merit and choir-schools of surpassing excellence; who installed their daughters, with generous dowries, in genteel convents; and whose tombs were graced with the best available ornamentation. Among such wealthy patrons was the Duke of Berry, for whom in the early fifteenth century the three Limburg brothers created the illuminated manuscript *Les Très Riches Heures du Duc de Berry*. This is the most famous of the prayer books called Books of Hours. These were lavishly illustrated volumes used by the nobility for their private devotions. They contained, as a rule, scriptural texts with exegesis and popular religious legends; sometimes a meditation on the life of Christ; and occasionally a calendar. As a genre, they flourished in the last centuries of the medieval period; but they were no longer created once the printing press made the illuminated manuscript obsolete.

The tradition of private devotional writing did endure, however. During the seventeenth century,

Lancelot Andrewes, John Donne, and Thomas Traherne did superb work in this vein. And they had many successors during the nineteenth and twentieth centuries, in whom, unfortunately, piety was not sufficiently matched with talent — except, of course, for Christina Rossetti and Gerard Manley Hopkins.

If it is not too presumptuous, I would hope that the poems here introduced may be read as belonging in that old tradition. In calling the cycle "A Book of Hours," I aspire to a kinship with my mediaeval predecessors. Granted, the work is not lavishly illustrated, but my text does have things in common with their texts: it incorporates biblical quotations; it reflects on the life of Christ; and it follows the liturgical calendar in addressing that life.

A word is perhaps in order on the literary style employed. Mediaeval painters invariably executed religious themes as though Christianity was a contemporary reality, not a legacy from the past: they portrayed biblical characters in the costumes of their own day, and surrounded them with landscapes and buildings as familiar as last week's news. Similarly, the best poets, then and since, have usually tried to speak about religion in the language of their own day. This was true in the fourteenth century, with Richard Rolle de Hampole and William Langland. It was still true later, with John Donne, George Herbert, and Henry Vaughan. The Victorian poets, to their discredit, substituted Poetic Diction for living speech. But the twentieth-century religious poets, at their best, rediscovered a valid voice for their work by speaking in the accent of their time, the two most notable examples being T. S. Eliot and W. H. Auden. Nor was this shift merely a matter of linguistics: it was rooted, fundamentally, in a change of

attitude; in an insistence that religion, if it was to mean anything, had to be seen as a living truth, not as a museum piece. Just before the First World War, T. E. Hulme inaugurated the Imagist school, which cast aside the glucose conventions of the Romantics and concentrated instead on the use of exact and vital images. The Imagist school, as an organized movement, was short-lived. But its effect on the subsequent writing of verse was profound and lasting. I have learnt, I hope, from what that achievement had to teach.

Readers, however, will readily perceive in my text what appears to be an internal contradiction. While the poems themselves are cast in the language of today, the biblical quotations attached to them are not. They are, in fact, taken from the King James version of 1611. I make no excuses for this. Later translations cannot begin to match its vigor, eloquence, and cogency: they are written with the best of pastoral intentions, but they suffer from a collective tin ear; moreover, those who expel the King James version from the lectern (and, for that matter, those in the Anglican Communion who throw away the Book of Common Prayer and put in its place the dreadful Book of Alternative Services) fail in the first duty of worship, which is to offer God nothing but the best. I have done the best I can with the poems; but I would not dream of tampering with the quality of the Bible our forefathers knew and loved and learnt from. If that is a contradiction, so be it.

So was the Cross.

I. Concerning the Incarnation

A light to lighten the Gentiles,
and the glory of thy people Israel.

PRELUDE

Et incarnatus est
de Spiritu Sancto
ex Maria Virgine,
et homo factus est.

Any Sunday anywhere
in the wide and singing world,
the same words in countless
tongues, the same recollection:
as here, weekly,
to the fourth Gregorian tone
chanted, kneeling: ". . . and was
conceived by the Holy Ghost
of the Virgin Mary, and was made
man."

　　　Made man:
in a particular place at a particular
hour, and also in all
places at all hours:
this intersection of time
and eternity, this entry
into mortal flesh of immortality:
this is now and here
and everywhere and always Emmanuel,
God with us all. Amen.

Glory be to the Father,
and to the Son,
and to the Holy Ghost:
as it was in the beginning,
is now, and ever shall be,
world without end. Amen.

ANNUNCIATION

Before ever time
began, Gabriel, your
function had always been,
without beginning or end,
praise. Was it therefore
a kind of exile, to forgo
that timeless hymn
and enter time on a mundane
errand? Winging down
from the high courts of alleluia,
you cannot remotely have foreseen
how this terrestrial event,
which must for ever transform
your listener, would equally alter
you: how in the instant
of her mortal consent
your immortal soul
(ignorant until then
of anything except adoration)
would be touched all of a sudden
with human care; with love
for her in such acceptance
of unasked miracle, but also
with a kind of pity, unfamiliar
as death, a sorrow for the sword
that must inevitably in time
pierce her heart.

 Nothing
from then on for you
could ever be the same.
To be sure, you did return
promptly enough to your post.
But love drew you back,
again and again, to the beckoning
district of earthly need:
to reassure the just husband
in his doubt; to announce the birth
appropriately to shepherds; to send
the wise visitors from the East
home by a safe route,
and send the family away
out of danger by night
into Egypt, bringing them back
only after the threat
to the child's life was past.
All this in the infancy.
Then, in the manhood, again
the thithering journeys: to minister
where he prepared himself
in the desert; to help him bear
his agony in the garden; and finally
to sit by the empty tomb
triumphant and proclaim his rising
from the dead.

 Oh, but what joy
you had of his coming home!
Others above had felt
his absence, but only for that

infinitely brief moment
which equals a man's life
in the higher arithmetic. Whereas
you, Gabriel, had learnt
chronology, had tuned your mind
to the rhythm of days and months;
and for more than thirty years
sadly you had to count
the empty hours of separation.
Yes, you understood how,
without his redeeming work,
the earth would always remain
incomplete. But without his presence
heaven was incomplete, too;
and that, for you, was a long
grieving.

 So when the gates
lifted up their heads
and the King of glory came in,
none in the heavenly host
more than you, angel,
rejoiced; and none more proudly
sang the eternal song
around the throne, where he sat
again now and for ever
on the right hand of the Father.

Lift up your heads, O ye gates,
and be ye lift up, ye everlasting doors;
and the King of glory shall come in.

NATIVITY

And it came to pass in those days,
that there went out a decree
from Caesar Augustus,
that all the world should be taxed.

It is, to say the least,
an inconvenience: having to go
all the way from Nazareth
to Bethlehem, simply to register
for taxes (payable without
recourse to the bloody Romans);
and this, of all times,
with his wife in her ninth month;
not to mention, either,
there's no public transportation
between Galilee and Judaea,
so she'll have to ride — virtually
a guarantee she'll go into labor.

The miles unfold, interminable
under the patient hooves:
it takes the best part
of a week; and wouldn't you know it,
when they get there
the inn's fully booked,
and they have to doss down
in the stable; where, sure enough,
the contractions begin almost
at once, too frequent
for any help to be fetched,
and he has to deliver her himself
on the straw-strewn floor,
wipe away the blood,
swaddle the small body

Her first-born son.

in a clean breechcloth
from the saddlebag, and contrive
a makeshift crib in the manger
adjacent, with mere hay
for bedding — a fine start
this is, for the son
born of maid and miracle!

SALUTATION

*And there were in the same country
shepherds abiding in the field,
keeping watch over their flock by night.*

Winter: night watch
on a bleak hill, the flock
huddled together for sleep,
one ewe at the edge
standing, alert for predators:
two men snoring
under rough cloaks
beside the fire: between them
silent, hunkered down
over the warmth, a boy,
his turn to wake,
replenish the dying wood;
whose pinpoint of flame
echoes the tall stars,
light-years distant,
unseeing, indifferent.

 Suddenly,
light: a vast radiance
encompassing hill and sheep
and men, outshining fire
or stars: and there in the midst
a Presence, inhuman, come
from some unimaginable Elsewhere,
daunting: curiously, though,
the beasts sleep on, oblivious,
even the sentinel ewe
is apparently unaware of anything
worth attention: but the boy

shivers with dread: cautiously
he stretches out a foot
and nudges his two companions
awake; who also both
panic.

 "Fear not,"
they are bidden, and somehow the tone
instantly reassures them: they listen
with quiet, amazed hearts
to what they are told, and at once
believe: this news
is what their circumstance
has always awaited: the poor
alone have earned the right
to be the first to know;
will inherit the earth.

 Subsequently
the enormous hullabaloo overhead
of angels shouting glorias
and so on seems immaterial:
what really matters
is to leave their flock in the care
of this unforeseeable Guardian
and make their way immediately
down the hill, to visit
the Truth; and to bear witness
afterwards of a world irrevocably
changed.

And they came with haste,
and found Mary, and Joseph,
and the babe lying in a manger.

For us here,
countless generations later,
their surviving words
yearly count as a summons:
that we too, like them
straightway, should now go
even unto Bethlehem
to see this thing
which is come to pass, which the Lord
hath made known unto us.

EPIPHANY

The kings of Tarshish and of the isles
shall bring presents:
the kings of Arabia and Saba
shall offer gifts.

Look: three kings
kneeling wordless to honor
the as yet inarticulate Word,
every year born
in the same squalid shed:
history calls them wise,
discerning whereabouts Wisdom
should be found: not in the palaces
of royal privilege or moneyed
respectability, but down here
in the dirt, beside illiterate
shepherds and malodorous beasts:
richly casketed, their gifts
seem almost absurdly
out of place, and themselves
feel unexpectedly ashamed:
but this, this is their miracle,
to know, all of a sudden,
fellowship for the first time
with the poor, and even somehow
kinship with the ox and ass
attending: who recognize and revere
the Truth sent from above,
and fix their long gaze
(intent, unanimous) upon
the incarnate face of Love.

The ox knoweth his owner,
and the ass his master's crib.

CIRCUMCISION

And when eight days were accomplished
for the circumcising of the child, it is written
that his name was called Yeshua,
which was so named of the angel
before he was conceived in the womb:
Yeshua ben Yosef, Nazarene
of the house and lineage of David;
a Jew under the Covenant,
come to renew the Law.

Glint of light on the blade:
with a deft flick of the wrist,
the Mohel severs the particle
of skin: twitch of blood
and a small, hurt cry:
it is all done quickly,
efficiently; now he belongs
among his people, and wears
their distinguishing sign.

If, sadly, his followers
later abandoned the rite,
that in itself was the least
of their assaults on Temple
and Torah: their antipathy
swelled like a monstrous fistula
in the Gentile heart, to pour
its poison worldwide

and centuries long on every
generation of the Chosen people.

Oberleutnant Klein, in Cracow,
parades all the boys
in the local Catholic school
on the playground, and orders them
to drop their pants for inspection:
Korporal Fritsch, with diligent
thoroughness and no shame,
examines each penis,
looking for hidden Jews;
betrayed by his naked glans
and terrified, Julius Meyer,
who has passed as Jan Malinowski
on his forged identity card,
is marched away — another
candidate for the cattle-cars,
destination Auschwitz-Birkenau.

Footnote: his uniformed murderers,
who call themselves Christians,
would be deeply affronted if told
their Christ was a Jew:
a practicing Jew, devout
in the long faith of his fathers;
orthodox — and, of course, circumcised.

*And he received the sign
of circumcision,
a seal of the righteousness
of the faith.*

EGYPT

Many, many by night,
similarly, have fled: warned
only just in time,
and sneaking across the nearest
frontier minutes ahead
of the licensed thugs; escaping.
How many more, though,
have not! Who had no warning
or lacked the contacts to organize
a getaway: to whom there came
in the cold small hours
the dreaded knock at the door;
for whom in their innocence waited
variously the Stalinist bullet
in the back of the neck, the Inquisition's
fire, or the sword of Herod.

Moonlight dapples the desert
where the sand is ridged by the winds
off the Red Sea: here
her ancestors passed in the opposite
direction, also to escape;
here her remote descendants
will waste the invading tanks;
near here, the tablets
of the law came down
from on high, defining a faith
and a people — this place
is holy ground. Unconscious

Ye were strangers in the land of Egypt.
Out of Egypt have I called my son.

of history or future but knowing
only what has to be done
to survive, the old man
concentrates on landmarks, distances,
the careful husbanding of strength
and supplies. And is it here
on this journey the aphorism
begins, that whoever saves
a life, saves a world?

VOX IN RAMA

Then Herod, when he saw
that he was mocked of the wise men,
was exceeding wroth,
and sent forth,
and slew all the children.

The joy of our heart is ceased:
our dance is turned into mourning.

In Rama was a voice heard,
lamentation and great mourning:
Rachel weeping for her children
put to the sword; in Bethlehem
and all the coasts thereof,
two years old or under,
at a king's malign word.
Nor only there
or then, but also now
and here, in our time,
our place: in Terezín, Buchenwald,
Bergen-Belsen, Auschwitz,
Treblinka, Dachau, and a hundred
other eugenically planned
extermination centers, where
depravity massacred the innocent
for no other reason
than who they were. History
cannot silence the cry:
century after century,
Rachel weeping for her children;
and will not be comforted —
because they are not.

And behold,
there was a man in Jerusalem,
whose name was Simeon;
and the same man
was just and devout,
waiting for the consolation of Israel;
and the Holy Ghost was upon him.
And he came by the Spirit
into the temple:
and when the parents
brought in the child Jesus,
to do for him
after the custom of the law,
then took he him up in his arms,
and blessed God.

In the entrance court of the temple,
the seats of the money-changers:
who for a mulcting fee
translate to local currency
Roman denarius, Greek
obol, or coin acquired
in trade with Egypt and Syria;
beside them, variously,
the stalls of merchants, selling
overpriced souvenirs,
philacteries, menorahs, mezuzot,
and for those come to dedicate
a son the requisite pair
of turtledoves or two young
pigeons, according to the law.

They pass through with their purchase.

Awaiting them in the inner sanctuary,
one old man:
who has waited, decades long,
for this hour, to see
this child, this
salvation, and takes him up
in his arms and thanks God
for this light, this
glory; and begs leave
now to depart in peace.

Candles gleam, sturdy
in the incense-laden gloom,
linger on the optic nerve
briefly as she closes her eyes
in resolve, to steel her heart
against the sharp sorrow
foretold: from now on
there is no turning back;
this moment, this
commitment, this journey
here begun leads
ineluctably years hence
to condemnation, to a nailed death
outside the city walls —
this is hard, this
consequence, this bleak outcome
of having so blithely said
to the angel, "Be it unto me
according to thy word":
hard enough anyway
simply to give over
her son to God; but oh,
harder harder harder
to deliver him, knowingly,
into the hands of wicked men.

A light to lighten the Gentiles,
and the glory of thy people Israel.

The canticle rises up
annually from robed choirs
before evening altars:
generation after generation
gives due thanks
for having seen at Candlemas
such light, such
glory; and having seen
salvation, departs in peace.

POSTLUDE

And thou Bethlehem,
in the land of Juda,
art not the least
among the princes of Juda.

Consider, pilgrim, consider:
this Bethlehem is not
that imagined place
of carols and altar paintings,
vivid in childhood memory
but never before visited.
What you encounter here,
with a vague sense of disappointment,
is yet another undistinguished
and dusty Middle-East
small town, as much
Arab and Jewish as Christian.
The tour bus stops
by pre-arrangement next to the shops,
where hucksters of no clear
affiliation peddle cheap
picture postcards, medals,
and expensive but dubious relics
of obscure saints: commerce
at Christmas is just as rife
here, where Christ was born,
as back home in Toronto,
where Christ is born annually
amid the celebratory bells
of cash registers devoted
to greed and pop music
devoted to cash; the difference
is minimal.

 Down the street
 the Church of the Holy Nativity
 is squabbled over splenetically
 for first dibs on the customers
 by competing Catholic friars
 and Orthodox priests: you enter
 a little sadly, then,
 this holy spot,
 wholly unprepared for how
 it has been tricked out
 with every tasteless gaud
 vulgarity and money combined
 can buy; this is not
 that lowly stable
 where an unequivocal truth arrived
 to comfort the downtrodden
 and afflict the smug. Yet,
 precisely because of the contrast
 (you realize with a pang as you kneel
 before the shrine), the Incarnation
 is always necessary: then
 and now, as it spins in the gravity
 of our flaws, year upon year,
God so loved the world, our earth stands in need
that he gave his only begotten Son, of redemption; and ever will,
that whosoever believeth in him world without end. Amen.
should not perish,
but have everlasting life.

II. Concerning the Ministry

Behold the Lamb of God,
which taketh away
the sin of the world.

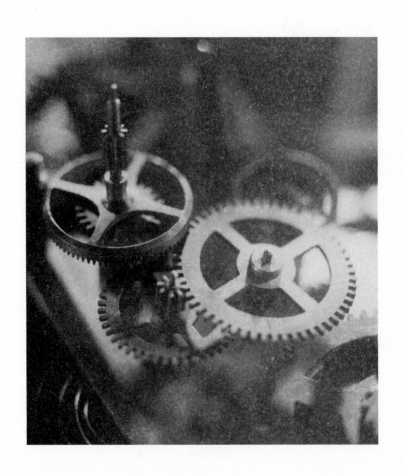

JORDAN

First John, striding
out of the Betharaba wilderness
to the riverbank, his cousin:
baptizing with water and prophesying
that one should come after him,
mightier than he, whose shoes
he was not worthy to unloose;
who would baptize with the Holy Ghost.

Priests since, perennially
at every font, have made
the young by baptism partakers
in his everlasting kingdom,
and also others such
as are of riper years,
signing them with water
in the Name of the Father, and of the Son,
and of the Holy Ghost: who exercise
by right of apostolic succession
this power and duty,
to receive alike children
and elders into the company
of all faithful people;
that they become for ever
sons and daughters of God.

He goes down into the water:
it closes over his head,
clear in the spring air,
benedictive: then he surfaces,
and sets his foot on the road
that will lead inexorably to where
a tall tree waits
on a harsh hill; to this
end was he born, and for this
cause came he into the world,
to bear witness to the truth.

Out of the sky, a dove
descending; lighting upon him
like a ratification; and a voice.

. This is my beloved Son,
in whom I am well pleased.

*And they brought unto him
all sick people that were taken
with divers diseases and
torments, and those which
were possessed with devils, and
those which were lunatick,
and those that had the palsy:
and he healed them.*

Saturday night: as usual
extra busy, crowded:
normal inflow of strokes,
coronaries, burn victims,
concussions, galloping infections,
sports injuries, rapes,
accidental or intentional overdoses,
food poisoning, allergy
attacks: but in addition,
this being the weekend,
the customary overload of cases
directly related to alcohol:
men women children
maimed by impaired drivers,
partygoers knifed
or shot, solitary drinkers
gripped by hallucination or seizure,
wives pulverized in domestic
violence; and dead on arrival,
the twenty-year drunk
who choked on his own vomit.

The stench and noise level
jar the senses: even
the staff, used to this,
can barely function with any
semblance of pity or understanding:
haste is all; the heart
has to acquire calluses.

If, this night,
he came back, unannounced,
simply walking in
through the swing-doors,
and healed, as long ago,
instantly, everyone he touched
(the man blind from birth,
lepers, the demented, the bedridden,
the sick with fever, the woman
in hemorrhage, Lazarus dead
and buried, the centurion's servant):
if that happened,
oh, to be sure, all of us —
doctors, nurses, patients,
visitors — would be equally astounded.
Miracle, some would call it:
others, an unexplained psychosomatic
phenomenon (though it's hard to see
the psychosomatic element involved
in a stab wound and its closure).
But afterwards, once the newspapers
had found some other sensation
to justify tall headlines
and high prices, which of us
then would think for a moment
that we, the ostensibly well,
were just as much in need
of healing as these afflicted?

For our soul is brought low,
even unto the dust:
our belly cleaveth unto the ground.
Arise, and help us:
and deliver us for thy mercy's sake.

And he opened his mouth,
and taught them, saying,
Blessed are the meek:
for they shall inherit the earth.

These are the dispossessed: who once
in far Eden strolled
under the new trees,
companionate among the creatures,
naming flowers: who evolved
elsewhere on fertile plains,
and even in deserts or on the barren
grounds above the treeline,
into a people at home
with the earth, reverencing all
within it; who never felt
themselves to be its owners,
simply its tenants, partners
there with beast, bird,
fish, and every other
living thing that breathed.

Whose free and equal place
among the species was usurped:
by fellowmen itching
for ownership and power and wealth:
who, to that end,
invented weapons, prisons,
slavery, racial laws,
money, and a whole apparatus
of inherited privilege: who became
lords over serfs and acres;
who saw the entire planet

as inferior, merely a resource
to be used, by what they blasphemously
called divine right.

These are the dispossessed, these meek
whose choiceless necks have bent,
age upon age, beneath
the yoke of Cain and all
his spoilt heirs, but who
nevertheless in the last age
(this is promised) shall inherit
the earth: in that day
of wrath and doom impending,
when he shall come to judge
the world: when none escape
their due reward or due
sentence, as in the book
exactly worded; when what
is pledged every day
in the canticle shall come to pass.

He hath put down the mighty
from their seat:
and hath exalted
the humble and meek.

PARABLES

They haunt the long arcades
of memory like admonitions, nagging
the conscience: the foreign tourist
who alone stopped to help
a mugging victim, while others
passed by on the other side,
refusing to get involved;
the wastrel son who incurs
wretchedly often from us
a knee-jerk rebuke
when what he really needs
is love, forgiveness; the despised
tax-collector who acknowledges
more readily his sins
than the sanctimonious pew-holder
who congratulates himself on his own
merits; and the wealthy man
whose tortured ghost begs
in vain for mercy after death,
who himself had shown in life
no mercy to the beggar
lying covered in sores
in the gutter outside his gate.

And we, too often
complacent, hear the parables
read again of a Sunday,
and go back out
into the weekday world, oblivious
of every least word.

PROPHECY

He was not the first Jew
in history, nor the last,
led away, like a lamb,
to the Gentile slaughterhouse:
but ever since Golgotha,
such killings have multiplied
exponentially, with no end
in sight, and most of them
either perpetrated or instigated
by the Church: pogrom, holocaust,
genocide, all the labels
fit our smug failure
to intervene; we are, by that
measure, accessory to murder.
How is it, then,
we ever had the effrontery
to call our era Christian?

THE TRIUMPHAL ENTRY

Palm Sunday: the choir
chants the antiphon of the proper,
"Hosanna to the Son of David":
the priest blesses and distributes
the palms: all present,
holding them, file
in procession around the aisles,
singing the ancient hymn
"All glory, laud, and honour
to thee, Redeemer King";
it is, this year
and every year, an echo
of that welcoming Hosanna
cried out in the streets
of Jerusalem to the just man
and lowly, having salvation,
riding in upon a colt,
the foal of an ass.

 Also,
it is preface: to a grim week
of betrayal, rigged trial,
and death: and in eight days
to that second and greater
triumph; his entry, and ours,
into eternal life.

III. Concerning the Passion

And he bearing his cross went forth into a place called the place of a skull, which is called in the Hebrew Golgotha.

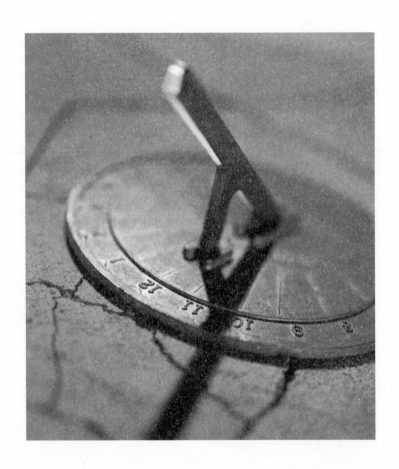

MAUNDY THURSDAY

I have given you an example,
that ye should do
as I have done to you.

Evening Mass, the hour
corresponding to the ritual time
of Seder, on the eve of Passover:
twelve men on benches
waiting, their feet bared:
the celebrant kneeling before them,
girded with a linen towel,
pouring water over
the right foot of each
from a jug into a basin,
then drying it with the end
of the towel: the choir chanting
meanwhile the ceremonial text
(quoted from the Last Supper,
his Seder with the original twelve)
which ordains this laving
yearly, this commemorative
of his stooped attentions.

Cold presses upward
from the stone floor: the pores
flinch at the water's touch,
and a chill invades the heart,
an accusation: which of us
has not, at some point
in our flawed lives, been Judas?

And ye are clean,
but not all.

FIRST STATION

*When Pilate saw
that he could prevail nothing,
but that rather a tumult was made,
he took water, and washed his hands
before the multitude, saying,
I am innocent of the blood
of this just person.*

We stand in the north aisle,
facing the framed scene:
irritated by this tiresome
intrusion of yet another
piece of religious squabbling
into his day (and at such
a godforsaken hour),
the Roman governor reluctantly
ratifies the death sentence that seems
so uncalled-for on the evidence
presented; and stiffly performs
the symbolic gesture of ablution,
thinking to exculpate himself
before the bar of time,
to rinse his hands of guilt
and shift the blame elsewhere.
It is an old and shameful story,
endlessly repeated, this
failure of competent authorities
to save the innocent: "It was not,"
they say, "our fault."
History begs to differ:
it is not a valid argument
to claim, at any Nuremberg,
"We were simply carrying out
the express will of the people";
any more than the flunky
is excused, either, who operated

the gas chamber and then
pleads in the dock, "Look,
I was just obeying orders."

There are no excuses:
responsibility rests on those
who choose their own acts,
their own omissions: the verdict
is quite clear; and unappealable.
But before we rush to condemn,
let us not forget
our own streak of similar
weakness: who can say
we too would not,
under pressure, be found
among the mockers, the smiters,
the drivers in of nails?

Father Thomas recites
the prescribed and penitential prayer,
appending to it the versicle
"We adore thee, O Christ, and we bless thee";
and we respond, in unison,
"Because by thy holy cross
thou hast redeemed the world."
Then we move on
to the next station, the first
verse of the "Stabat Mater,"
the crucifer leading the way,
bearing the processional cross
veiled in black linen
for this sad week.

CALVARY

Good Friday afternoon:
the Basilica of the Holy Cross
in Jerusalem: two cantors
standing in the midst of the choir,
robed in black, chanting
the Reproaches: "O my people,
what have I done unto thee?
Or wherein have I wearied thee?
Answer me. What more
could I have done for thee
that I have not done? I gave thee
to drink of the water of salvation
out of the rock: and thou
hast given me vinegar and gall."
Flanking them, north and south,
the choir responds, antiphonally:
"Holy God, mighty
God, immortal God,
have mercy upon us."
As, too, should we:
who severally and together, wherever
we are in the tainted world
and not in Jerusalem only,
must bear this earned reproach;
who crucify crucify crucify,
time and again, and lack
even the grace to hang
like malefactors to right and left
beside his faithful cross.

TENEBRAE

Three iron nails:
through the feet and traditionally
the hands, but in fact the wrists:
scourged, the back bleeds,
and thorned the head: thirst
torments the parched throat:
darkness falls; he dies.

In whose name many
bishops coldly have sent
other good men
to execution: and the sun hides,
ashamed, seeing it; year
after year he dies
on the same rood, recrucified.

Blow out the candles:
we have made an end
to truth, a darkness over
the whole earth: death
sits here, gloating;
and hope lies down,
sealed in hewn rock.

IV. Concerning the Resurrection

He is risen, as he said.
Come, see the place
where the Lord lay.

NEW FIRE

In him was life;
and the life was the light of men.
And the light shineth in darkness;
and the darkness comprehended it not.

After the darkness, light:
only hours ago
on Friday night, the last
and twenty-fourth candle
(the others already extinguished)
was carried out from the hearse
to the sacristy, still burning,
into a black absence; but now,
through that door at midnight,
the light returns like hope,
to lend its little spark,
undefeated, to the tall wick
awaiting it this vigil;
and the priest, striking flint
to fresh charcoal in the thurible,
blesses the new fire
and censes the light renewed.

The Lord hath chosen you
to stand before him,
to serve him,
and that ye should minister unto him,
and burn incense.

NIGHT OFFICE

The nuns assemble, to whom
this duty falls
every night of the year,
to rise in the small hours
and sing the obligatory psalms
with antiphons proper to the occasion.
All is customary, all
according to regular rubric.
But this night, exceptionally
ancient use interpolates
in the second nocturn briefly
a re-enactment of what happened
tomorrow (this by anticipation,
as so often in liturgy):
robed in a white alb
to represent the angel at the tomb,
a cantor sits at the "sepulchre"
in the north wall of the chancel,
with three sisters approaching
who represent the three women
coming with spices to embalm
the body. "Whom seek ye?"
chants the angel, gravely.
"Jesus of Nazareth," they respond.
"He is not here, he is risen,"
the angel proclaims. They bow
and return to their places in choir.

And that one moment,
ensconced in this obscure
monastic office, is the fountainhead
of all western theater.
The moment passes, but the truth
abides: Christ is risen.

He is risen, as he said.
Come, see the place
where the Lord lay.

THE GARDENER

*The first day of the week
cometh Mary Magdalene early,
when it was yet dark,
unto the sepulchre,
and seeth the stone taken away
from the sepulchre.*

End of pitch darkness:
night sky altering
to purple: under the trees
just enough visibility
to follow the garden path;
treading the air of sorrow
like a homing bird, to where
her heart lies interred.
Then, rounding the corner,
suddenly the shock: the stone
gone, the great stone
she has not thought how
to move, rolled back;
and echoing her inner emptiness,
the tomb also empty.

Grief floods her: this
is unbearable, this depredation,
this denial of any chance
to give the beloved his due
anointing after the custom
laid down. She weeps.

Last shred of hope:
perhaps this gardener
here, happening by,
dimly glimpsed through tears
in the half-light, knows
something, can tell her something
of who may have removed
the body, and where to.

"Mary," he says, gently.

The world stands still:
a great stone of grief
has been rolled away in an instant
from her heart, like a grain of sand;
nor ever can anything
take this joy
from her, not even
his soon and second farewell
on the high mount of ascension.
That, after all, will be only
a temporary separation, until
she shall follow where he
has led: unto the Father.

Then the same day at evening,
when the doors were shut
where the disciples were assembled,
came Jesus and stood in the midst,
and saith unto them,
Peace be unto you.

EASTER MORNING

Christ our Passover is sacrificed for us:
therefore let us keep the feast.

Easter is late this year:
already the daffodils have bloomed,
their gold matching the chasubles
of the Resurrection: Mrs. Trefusis
has placed two bunches
in gleaming brass vases
on the high altar, equidistant
between the flanking gold
of cross and candles; the flames
pale in the early shaft
of sunlight streaming in
at the east window, risen
again.

 "I have risen,"
the introit proclaims, jubilant
on the morning air, and "Alleluia,"
it concludes, "alleluia, alleluia,"
lifting up a word
silenced for six weeks
of abnegation and loss. "Alleluia,"
the gradual repeats, elaborate
between epistle and gospel;
also, after the creed,
the offertory. This is a music
redolent of spring and buried
life rising anew,

triumphant. Father Andrew
quietly plants redemption
upon the tongue; and we,
who have participated as best we can
and as most our guilt dictates
in the annual passion and death,
receive now, grateful,
this bread, this
body of saving love.

This do in remembrance of me.

V. Concerning the Ascension

Lo, I am with you alway,
even unto the end of the world.

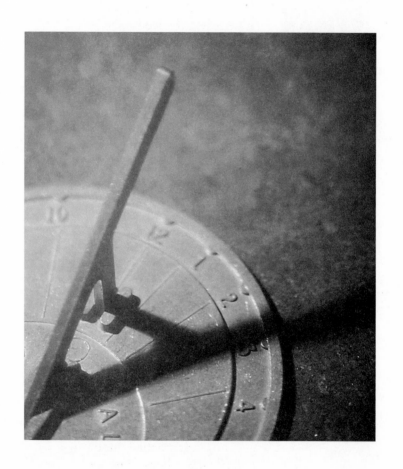

ENVOI

Whether or not we believe
in the legendary lifting off
from Mount Olivet is immaterial:
what matters is the willing acceptance
that he, in some fashion,
departed; and if a heaven
somewhere up in the sky
seems rather implausible
in this age of astronauts,
that need not affect
our faith in a real elsewhere,
even though it lacks
any kind of geography.

So let the myth stand,
for what it signifies: time,
after all, is merely an adjunct
of space, but eternity exists
outside of time or space:
we may not need now
to picture literal feet
vanishing into a literal
cloud; but we are much impoverished
if we cannot still pin
our trust on his actual return
to his Father's house, and hope
ourselves to follow him home.

To the which end, therefore,
let us hold fast
and fondly to that last
moment, glimpsing the farewell:
the green hill on a spring
morning; and him extending
scarred hands in benediction,
leaving his peace with us
for ever as he fades from sight.